Watersong Circle: A Diary of Flowers. An Anthology of Flowers and Verse, 2nd edition

*Copyright © 2011 by John R. Tuttle. All rights reserved.
No part of this book may be reproduced in any form or by any electronic or mechanical means including information storage and retrieval systems without written permission from the artist, except by a reviewer who may quote brief passages in a review.
Second edition, September 29, 2011.*

*This book is available direct from the publisher at www.tuttleworks.com
and online through Amazon and other fine booksellers.*

First published by John R. Tuttle, Inc. September 9, 2011

ISBN: 978-0615550138

Printed in the United States of America

Watersong Circle

A DIARY OF FLOWERS

spring rain—

all things on earth

becoming beautiful

— Chiyo-ni

Watersong Circle: A Diary of Flowers
Flowers of May

I missed the crocuses for this book. Way too late. I moved to Watersong Circle on April 22nd—well on the far side of winter and crocus-blooming season. I envision crocuses as little beacons announcing the next growing season. The first bright clarions of spring, their tiny purple and yellow floral cups punch up through the white snow of the winter landscape. It seems they love to come out of hibernation, sounding their tiny color-trumpets beside trickles of melting crystalline snow. Where were they the day before? It's a mystery to me.

Anyway, I missed the crocuses, as I was busy figuring out where to move—where to go to downsize. So, I dipped my artistic ladle into the glorious stream of spring flowers in my new neighborhood. On morning walks in the beauteous month of May, I "gathered" all the blooms that caught my camera's eye. These blooms became the basis for the book you are reading now—Watersong Circle.

I liked the street name, Watersong, but it had nothing to do with my reasons for moving from my home in Boulder to this new address. Besides being closer to my children, I could appreciate all the other practicalities and mundanities of the place. It was smaller. Good. Time to downsize. Time to rid myself of all the accumulations and encumbrances brought by thirty years of

migrating between the bright summers of enthusiasm and the grey winters of dusty disuse and storage. Deck varnish. A yellow sou'wester. Four boxes of sailing magazines—not much sailing in the Rocky Mountains. Or garnet panning, as I did in my days in Idaho. Table saw. Router. Drum sander. Drill press. Electric concrete mixer. Bonsai trappings. There were also enough tools to keep a '52 Dodge pickup truck running, and a telescope so large I could not move it without the help of two strapping university lads. Oh yes, and then there was golf—seventeen years of disproving my theory that I could eventually play it well.

Having too many hobbies is akin to having rusty old cars sitting around. Oh sure, they still run, but why start up an old heavyweight gas-guzzler when I can jump into a new battery-powered toy and get a million miles per gallon? There is one hobby, though—really more of a life's passion—that I always come home to: the art of photography.

But looking at my old camera gear inspired visions of distant parts of my life—visions I did not feel driven to revisit very often. And with the advent of digital cameras, all of my film, archaic wet chemistry, and museum of vintage film cameras seemed ready to be set free from that prison of storage. Why keep the stuff any longer? I gave it all away to a young man starting a photography school.

So, here I was with my latest-model digital camera on Watersong Circle in mid-April, in the idyllic setting of a cottonwood-shrouded creek. Ripe for evening walks, near the busy streets of town, but far from the hubbub.

The name Watersong Circle was probably chosen by a local

contractor to help sell his homes faster than the homes over on the unimaginatively named West 4th Street. But for me, Watersong characterizes the nature of beautiful plants. Each a glorious song emerging from water, channeled by xylem and phloem to leaf, bud, flower and root. Each a blooming beauty, a sculpture cast from a matrix of light, chlorophyll, soil, and air.

In my works, the ideal two-dimensional piece will engender the feeling of a three-dimensional sculpture. My goal is to create a deceptive and convincing quality of substance, as though the images were real objects that one could reach out and touch. I think of black-and-white works as silver sculpture, and color works as brass. My goal with these photos was to make the colors of my flower scenes feel as if reality had been carefully mixed with water, and molded into two-dimensional brass sculptures on canvas — a three-dimensional painting.

The sheer number of spring flowers around the Watersong Circle neighborhood began to wane in mid-June. Sure, the heavy-headed drowsy peonies were still coming on. And I was amazed at yet more new irises with their shaggy tongues and rippling robes. But the fireworks show was ending, giving way to the warm glowing hugs one feels after making love. To sleep until next year. The next cycle of flowers on Watersong Circle: the Colorado flowers of summer — on the far side of May. Perhaps the subject of another book.

I dreamed that, as I wandered by the way,

 Bare Winter suddenly was changed to Spring,

And gentle odours led my steps astray,

 Mixed with a sound of waters murmuring.

- Percy Bysshe Shelley

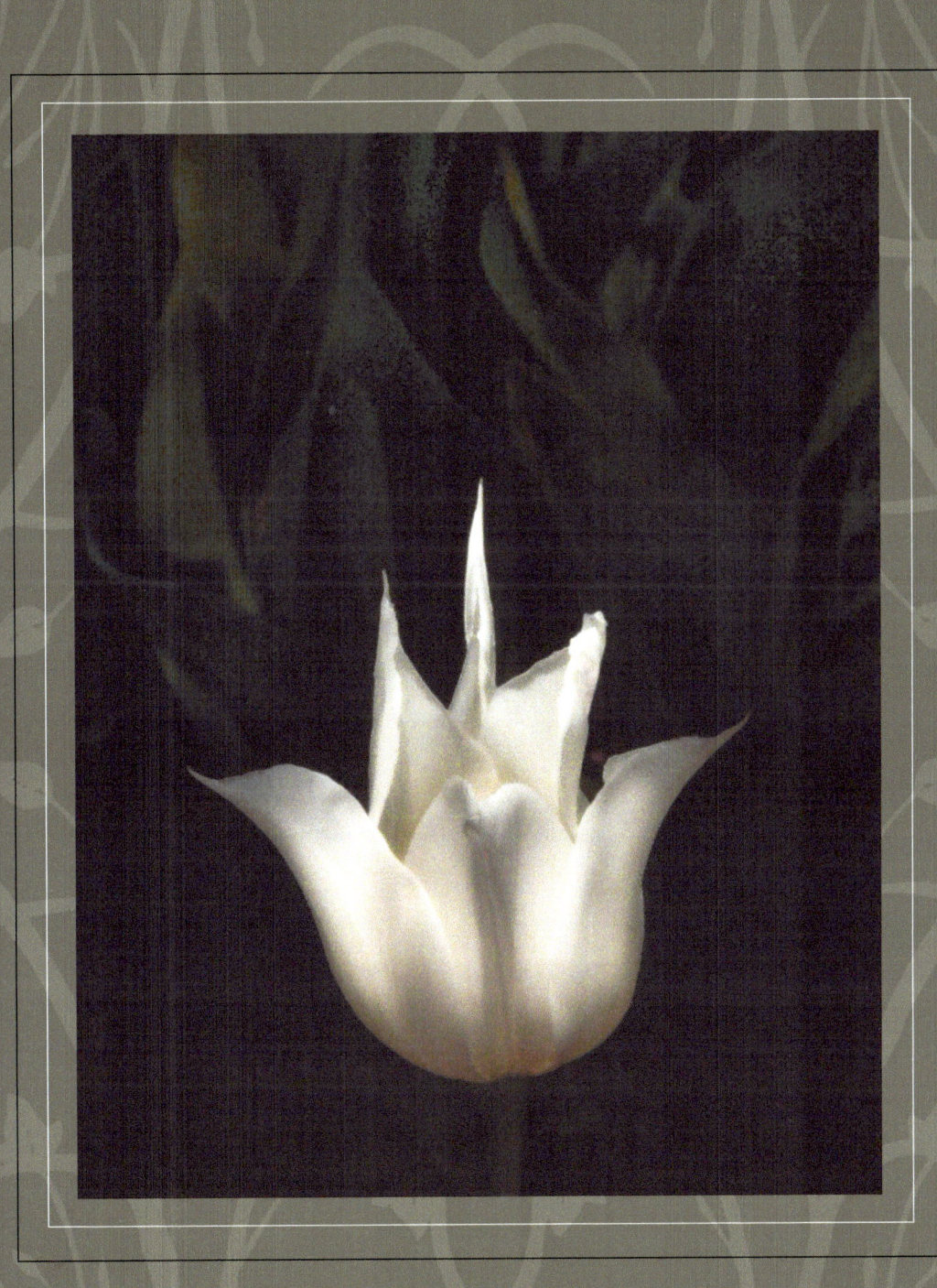

Plate 1

A thing of beauty is a joy for ever:

Its loveliness increases; it will never

Pass into nothingness; but still will keep

A bower quiet for us, and a sleep

Full of sweet dreams, and health,

and quiet breathing.

~ John Keats

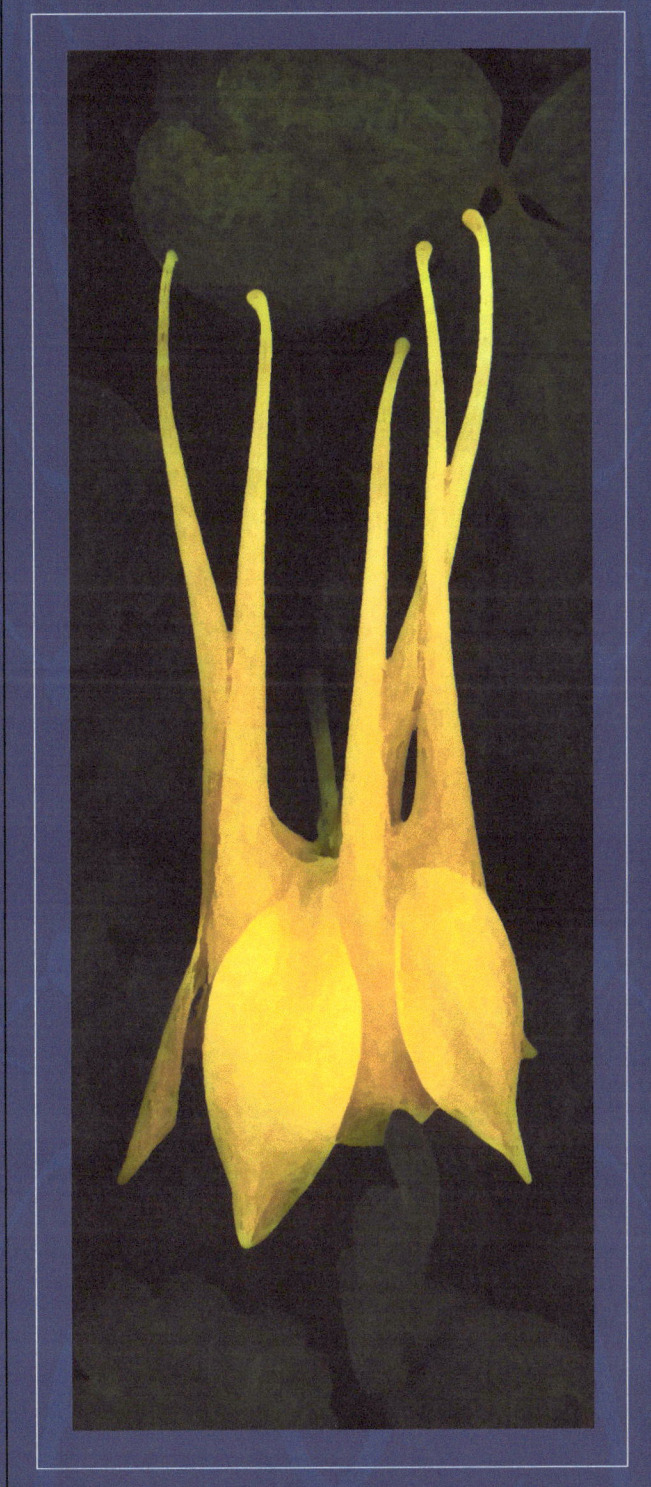

Plate 2

Earth laughs in flowers.

– Ralph Waldo Emerson

Plate 3

The temple bell stops but I still hear the sound coming out of the flowers.

~ Bashō

Plate 4

Through primrose tufts, in that sweet bower,

The periwinkle trail'd its wreaths;

And 'tis my faith that every flower

Enjoys the air it breathes.

~ William Wordsworth

Plate 5

When you have only two pennies left in the world,

buy a loaf of bread with one,

and a lily with the other.

~ Chinese proverb

Plate 6

Flowers have spoken to me more than I can tell in written words. They are the hieroglyphics of angels, loved by all men for the beauty of their character, though few can decipher even fragments of their meaning.

~ Lydia Maria Child

Plate 7

A little Madness in the Spring

 Is wholesome even for the King.

~ Emily Dickinson

Plate 8

Beauty is the promise of happiness.

~ Stendhal

Plate 9

Beauty is truth, truth beauty, — that is all

Ye know on earth, and all ye need to know.

~ John Keats

Plate 10

When April steps aside for May,

Like diamonds all the rain-drops glisten;

Fresh violets open every day;

To some new bird each hour we listen.

~ Lucy Larcom

Plate 11

Cherish your visions; cherish your ideals;

cherish the music that stirs in your heart,

the beauty that forms in your mind,

the loveliness that drapes your purest thoughts,

for out of them will grow delightful conditions,

all heavenly environment;

of these if you but remain true to them,

your world will at last be built.

~ James Allen

Plate 12

In all places, then, and in all seasons,

Flowers expand their light and soul-like wings,

Teaching us, by most persuasive reasons,

How akin they are to human things.

And with childlike, credulous affection

We behold their tender buds expand;

Emblems of our own great resurrection,

Emblems of the bright and better land.

~ Henry Wadsworth Longfellow

Plate 13

This outward spring and garden

are a reflection of

the inward garden.

~ Rumi

Plate 14

It is a golden maxim

 to cultivate the garden for the nose,

and the eyes will take care of themselves.

~ Robert Louis Stevenson

Plate 15

The beautiful rests on

the foundations of the necessary.

— Ralph Waldo Emerson

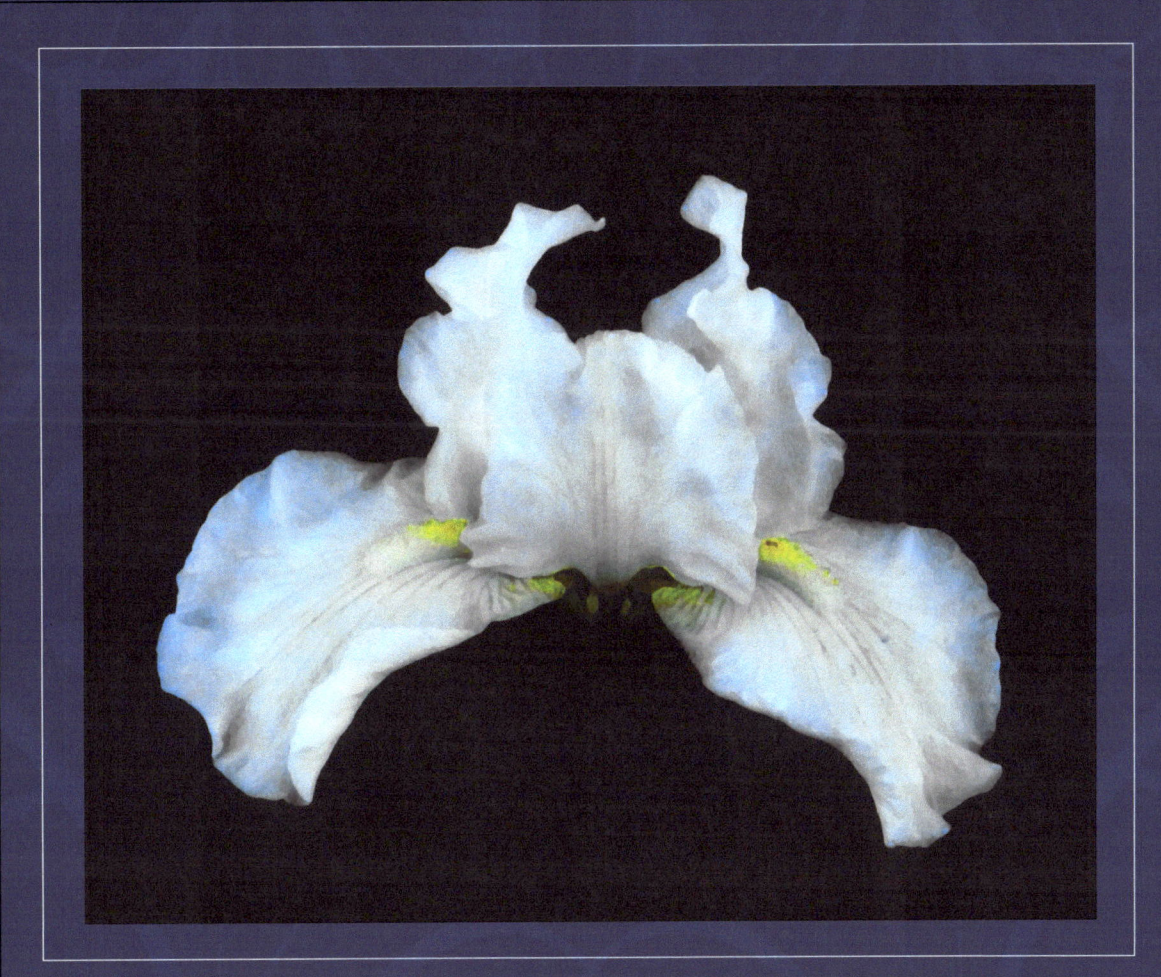

Plate 16

Flowers are Love's truest language.

~ Park Benjamin

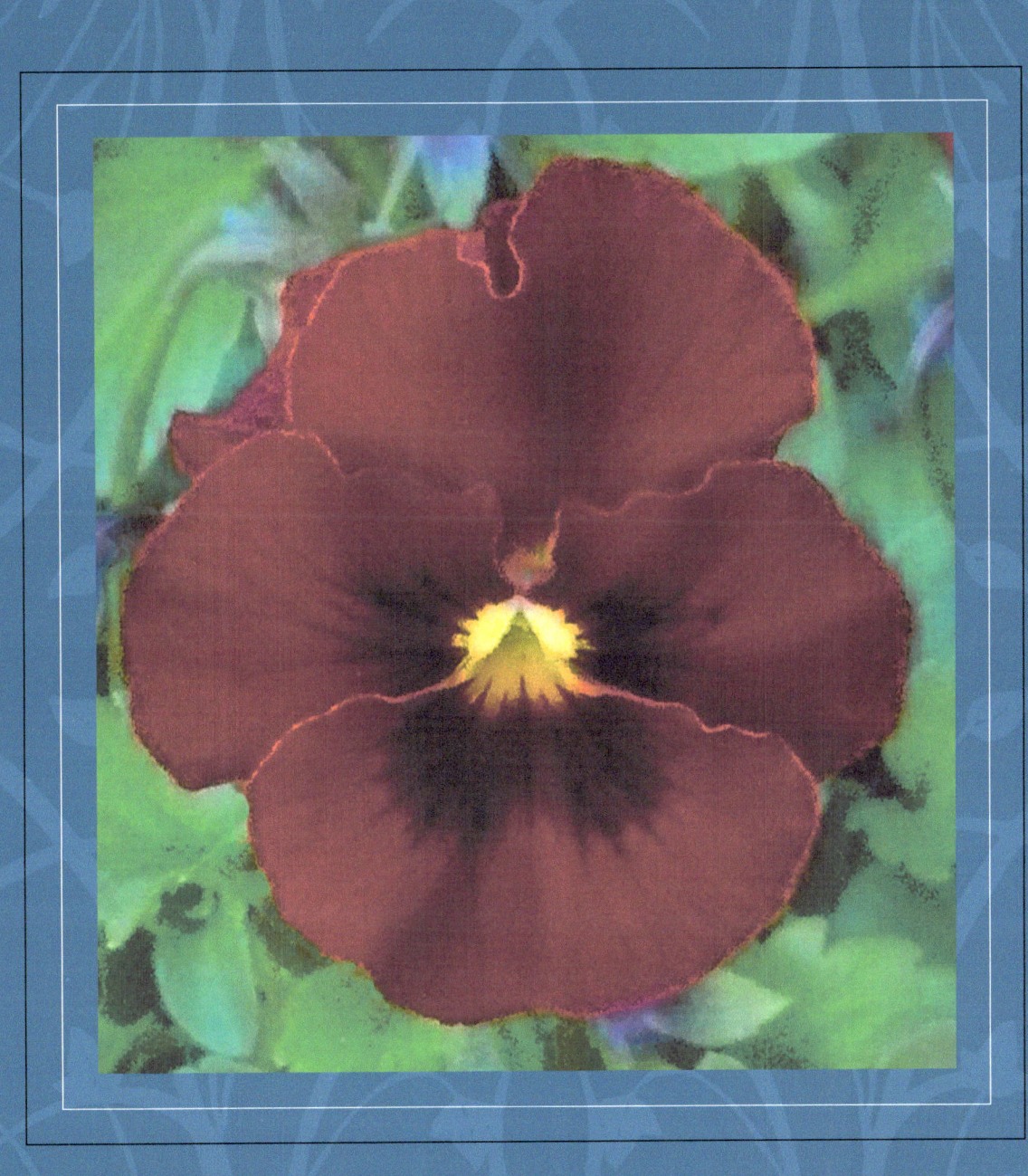

Plate 17

I know not which I love the most,

Nor which the comeliest shows,

The timid, bashful violet

Or the royal-hearted rose:

The pansy in her purple dress,

The pink with cheek of red,

Or the faint, fair heliotrope, who hangs,

Like a bashful maid her head.

~ Phoebe Cary

Plate 18

Roses, and pinks, and violets, to adorn

The shrine of Flora in her early May.

— John Keats

Plate 19

Sweet May hath come to love us,

Flowers, trees, their blossoms don;

 And through the blue heavens above us

The very clouds move on.

~ Heinrich Heine

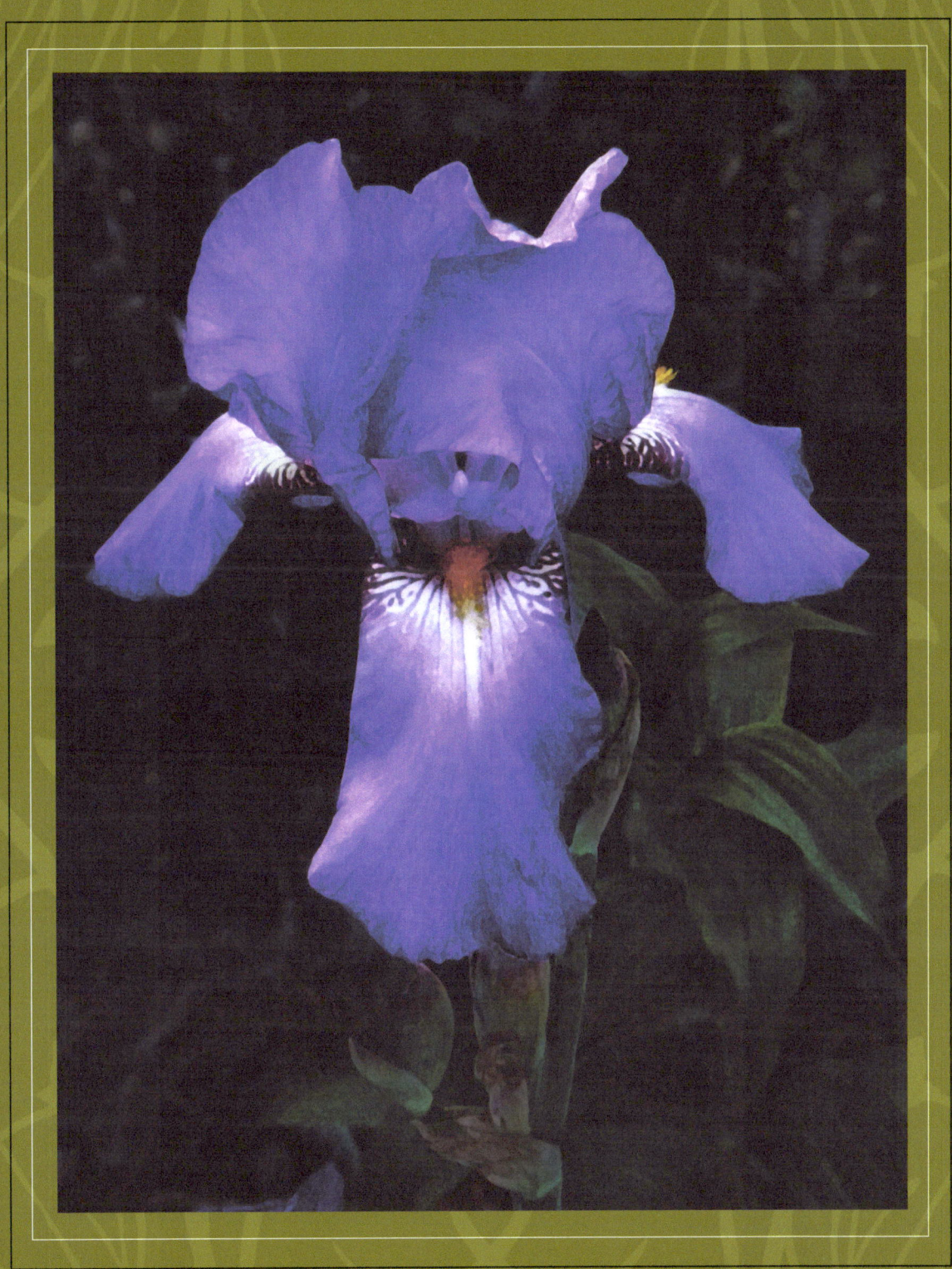

Plate 20

Break open

A cherry tree

And there are no flowers,

But the spring breeze

Brings forth myriad blossoms.

~ Ikkyu Sojun

Plate 21

If you truly love Nature,

you will find beauty everywhere.

~ Vincent Van Gogh

Plate 22

The month of May was come,

when every lusty heart

 beginneth to blossom, and to bring forth fruit;

 for like as herbs and trees

bring forth fruit and flourish in May,

in likewise every lusty heart

 that is in any manner a lover,

springeth and flourisheth in lusty deeds.

 For it giveth unto all lovers courage,

 that lusty month of May.

 ~ Sir Thomas Malory

Plate 23

Flowers... are a proud assertion that a ray of beauty outvalues all the utilities of the world.

− Ralph Waldo Emerson

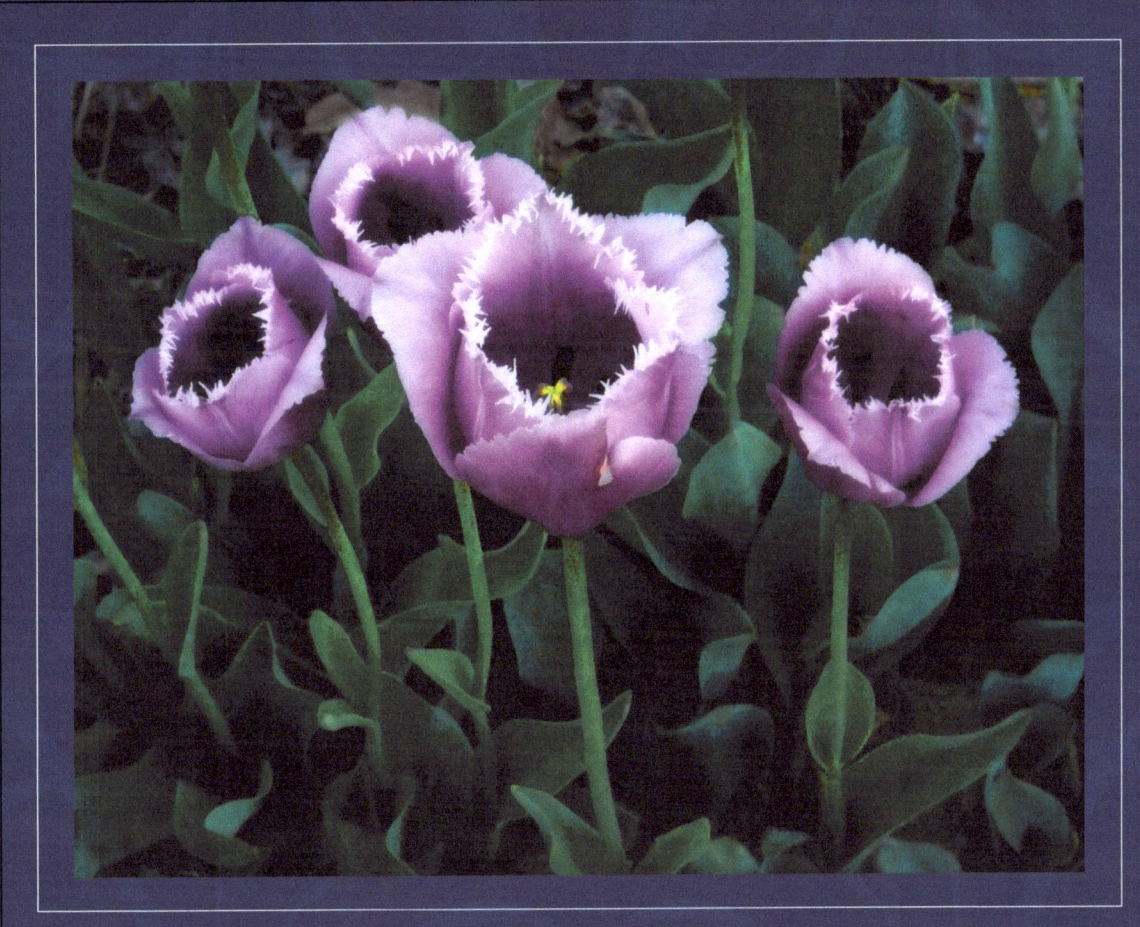

Plate 24

Nothing is so beautiful as Spring.

~ Gerard Manley Hopkins

Plate 25

South Winds jostle them —

Bumblebees come —

Hover — hesitate —

Drink, and are gone —

Butterflies pause

On their passage Cashmere —

I — softly plucking,

Present them here!

— Emily Dickinson

Plate 26

A morning-glory at my window satisfies me more

than the metaphysics of books.

~ Walt Whitman

Plate 27

Always remember the beauty of the garden,

for there is peace.

~ Author unknown

Plate 28

I have a garden of my own,

Shining with flowers of every hue;

I loved it dearly while alone,

But I shall love it more with you.

~ Thomas Moore

Plate 29

All day in the green, sunny orchard,

When May was a marvel of bloom,

I followed the busy bee-lovers

Down paths that were sweet with perfume.

— Margaret Elizabeth Sangster

Plate 30

Bread feeds the body, indeed,

 but flowers feed also the soul.

~ The Koran

Plate 31

For winter's rains and ruins are over,

And all the season of snows and sins;

The days dividing lover and lover,

The light that loses, the night that wins;

And time remembered is grief forgotten,

And frosts are slain and flowers begotten,

And in green underwood and cover

Blossom by blossom the spring begins.

~ Algernon Charles Swinburne

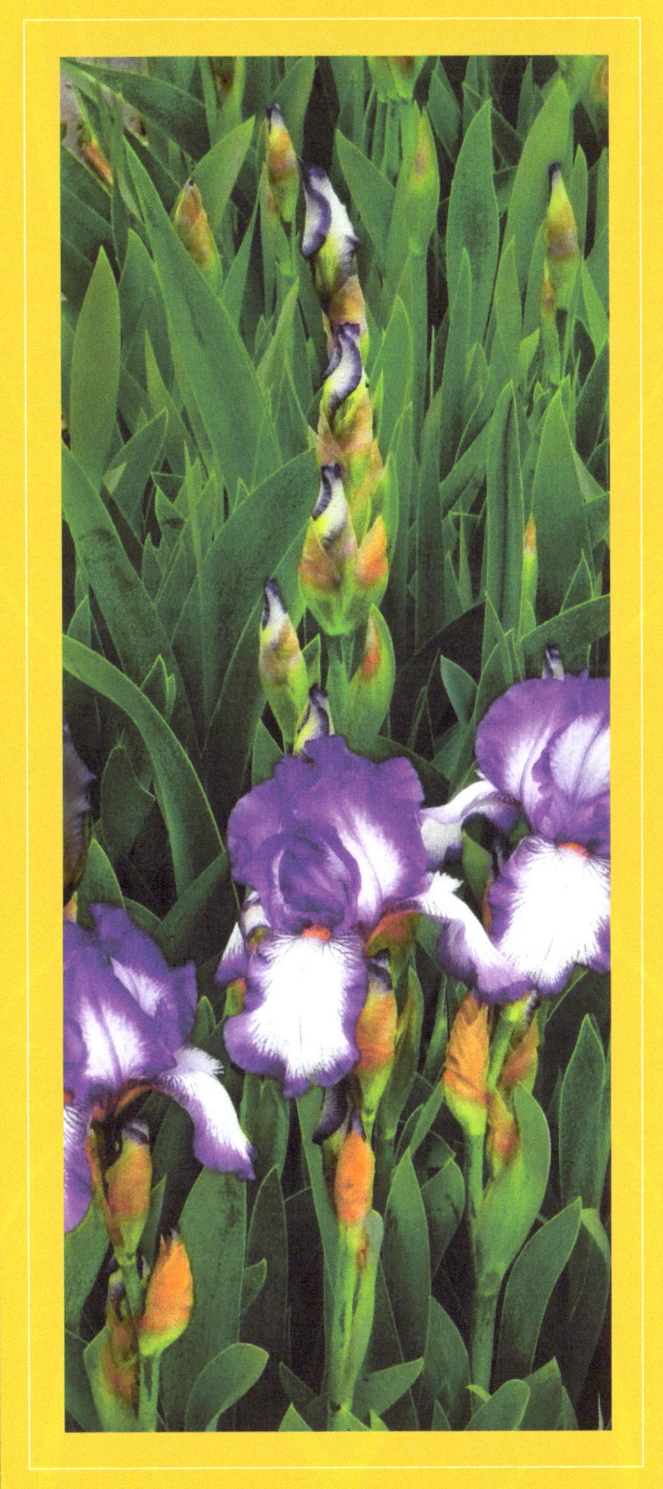

Plate 32

Love of beauty is Taste.

The creation of beauty is Art.

~ Ralph Waldo Emerson

Plate 33

And then my heart with pleasure fills

And dances with the daffodils.

~ William Wordsworth

Plate 34

In the dooryard fronting an old farm-house

near the white-wash'd palings,

Stands the lilac-bush tall-growing

with heart-shaped leaves of rich green,

With many a pointed blossom rising delicate,

with the perfume strong I love,

With every leaf a miracle—and from this bush

in the dooryard,

With delicate-color'd blossoms and heart-shaped

leaves of rich green,

A sprig with its flower I break.

~ Walt Whitman

Plate 35

When I went out

In the Spring meadows

To gather violets,

I enjoyed myself

So much that I stayed all night.

~ Yamabe no Akahito

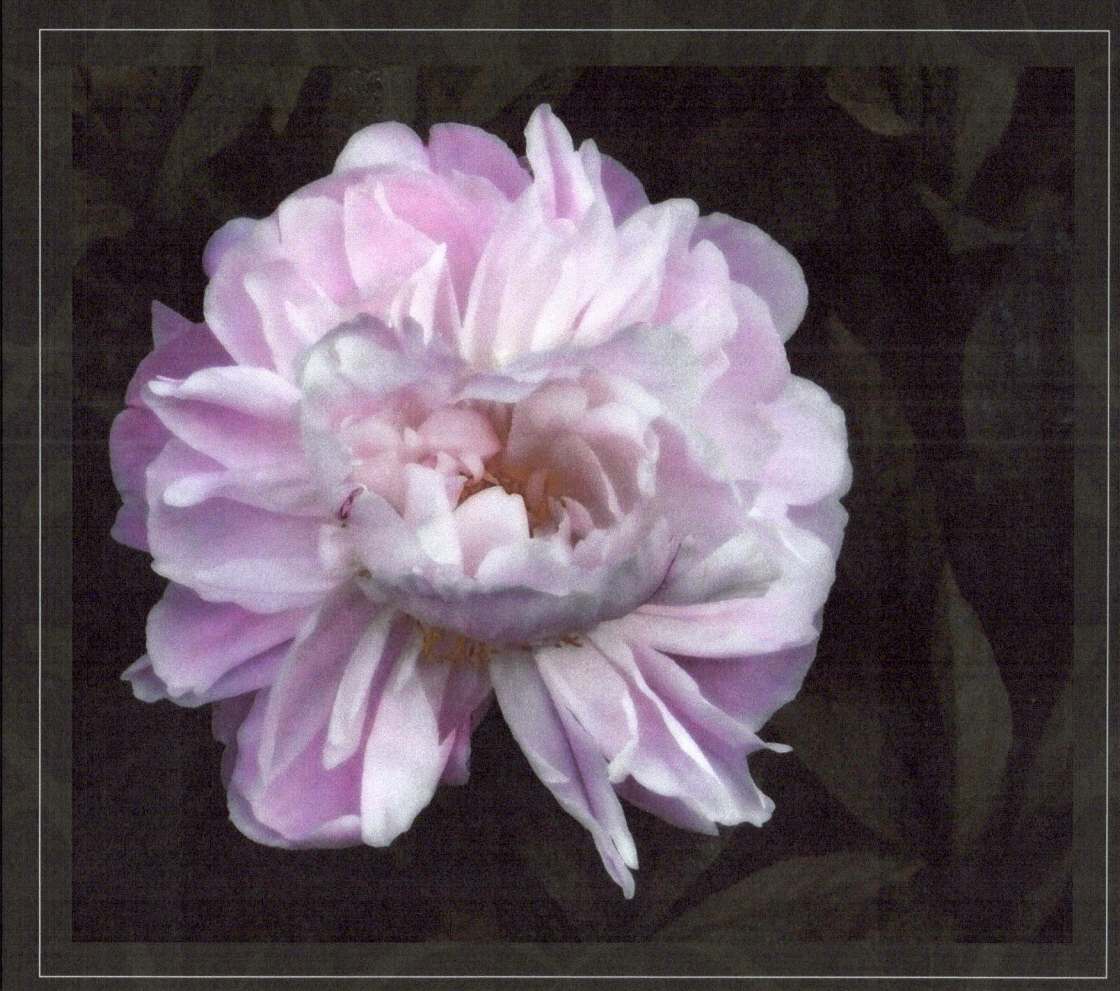

Plate 36

Everything has its beauty, but not everyone sees it.

~ Confucius

Plate 37

Give me odorous at sunrise a garden of beautiful flowers where I can walk undisturbed.

~ Walt Whitman

Plate 38

Nothing is more the child of art than a garden.

~ Sir Walter Scott

Plate 39

Ah! my heart is weary waiting,

 Waiting for the May—

Waiting for the pleasant rambles

Where the fragrant hawthorn-brambles,

With the woodbine alternating,

 Scent the dewy way.

Ah! my heart is weary, waiting,

 Waiting for the May.

~ Denis Florence MacCarthy

Plate 40

If we could see the miracle of a single flower clearly

our whole life would change.

— Author unknown

Plate 41

The butterfly is a flying flower,

The flower a tethered butterfly.

~ Ponce Denis Écouchard Lebrun

Plate 42

*Never yet was a springtime,
when the buds forgot to bloom.*

~ Margaret Elizabeth Sangster

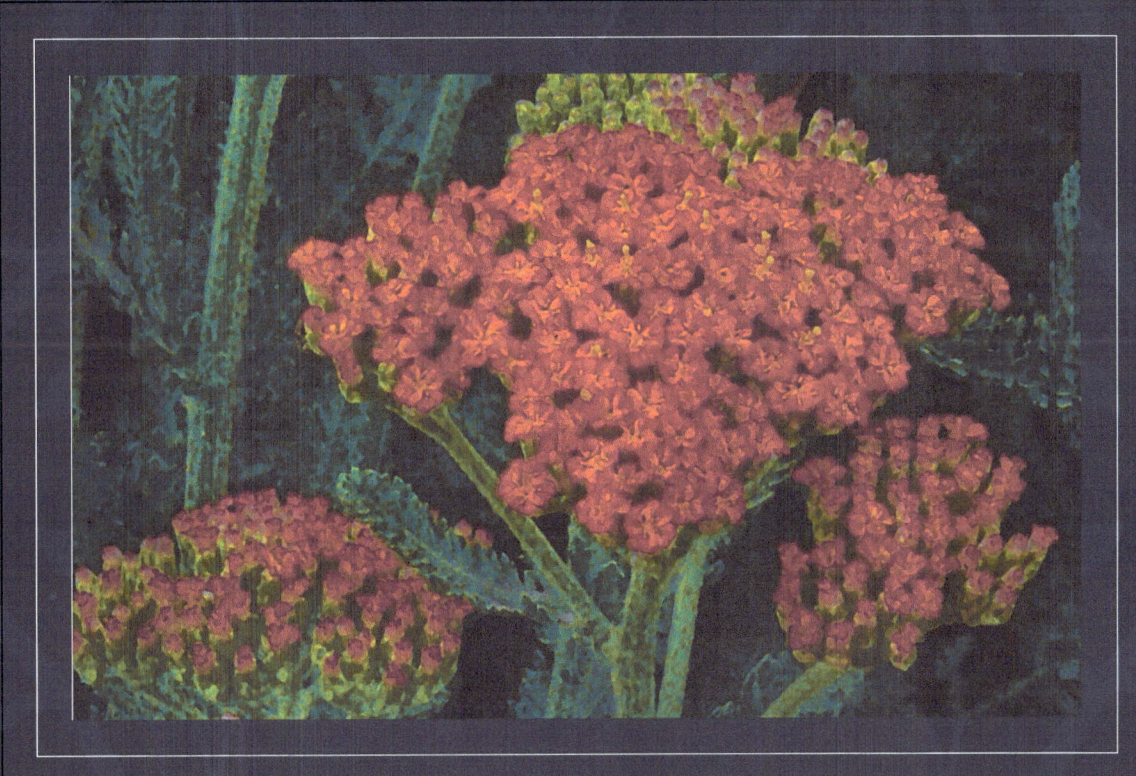

Plate 43

A garden is a lovesome thing!

~ Thomas Edward Brown

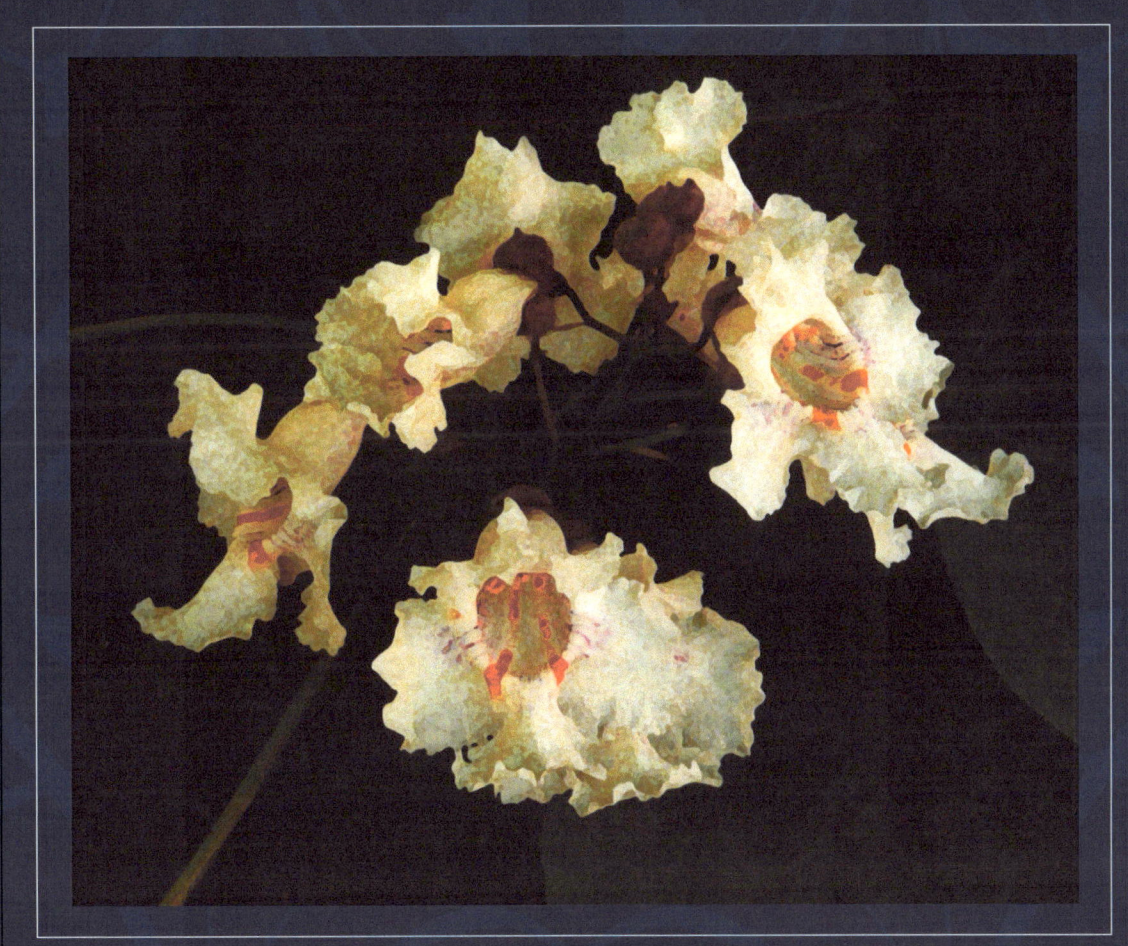

Plate 44

Beauty is not caused. It is.

~ Emily Dickinson

Plate 45

With a few flowers in my garden,

 half a dozen pictures and some books,

I live without envy.

 – Lope de Vega

Plate 46

Now the bright morning-star, Day's harbinger,

Comes dancing from the East, and leads with her

The flowery May, who from her green lap throws

The yellow cowslip and the pale primrose.

Hail, bounteous May, that dost inspire

Mirth, and youth, and warm desire!

Woods and groves are of thy dressing;

Hill and dale doth boast thy blessing.

Thus we salute thee with our early song,

And welcome thee, and wish thee long.

~ John Milton

Plate 47

What potent blood hath modest May.

~ Ralph Waldo Emerson

Plate 48

A sensitive plant in a garden grew,

And the young winds fed it with silver dew,

And it opened its fan-like leaves to the light,

and closed them beneath the kisses of night.

~ Percy Bysshe Shelley

Plate 49

The bee and his brethren—bugs,

bats and birds—with their combined

frenetic and sustained energies,

and by the irony of unwitting

pollinations of countless generations,

have borne to the world the entire

floral universe,

and thus the flowers of May

at Watersong Circle.

~ Tuttle

Plate 50

Biography

John R. Tuttle has always been an artist. He was born in Spirit Lake, in northwest Iowa, and raised in Spencer, another little farm town twenty miles away. At the age of four, he began piano lessons. Eight years later, he built his first darkroom with the help of his cousin Morrie, who lived next door. Morrie had been in France, where he had steeped himself in fine art and music, cultivating his knowledge and sensibilities. Home for a spell, he was gracious enough to share the wonders of the outside world with his cousin—Little Johnny, as Tuttle was known—who had also possessed a keen interest in such things from an early age.

Tuttle's growing enthusiasm for art was coincident with his introduction to the world of engineering—another auspicious occasion, which began with rocket design and construction at Jefferson Junior High School. He later received a bachelor's degree in electrical engineering from the University of Minnesota, and a master of science degree in electrical and computer engineering from the University of New Mexico. He worked as a musician both before and during his college years, touring with The Four Seasons, Freddy Cannon and others. And during the Vietnam War, he served in the US Navy.

As a professional engineer, Tuttle's career includes over thirty-five years of research and development in the high-tech industry. He holds over one hundred technology patents for his many inventions, and shows no signs of idleness. His latest creation is a turbine-free wind energy system—a revolutionary marvel of technology that can harness a force of nature. Converting wind to electricity, his WindPipe technology works simultaneously to protect and benefit the environment. And no surprise, in this book, this decidedly pro-nature guy—this artist/engineer—shares his digital photographs of the flowers of May, as well as the technology and techniques he used to capture them. Another of his inventions pertains to photographic technology, improving the way in which digital cameras capture images. Tuttle is looking forward to having such a camera to hold in his own hands one day, and he hopes others can benefit as well, in order to ensure that all photographs are 'keepers.'

The power and grace of Tuttle's art emanate from the images' visceral and sublime messages. Of his work, he says:

> It is the duty of the artist to honor basic human proclivities and experience in his works. I therefore try to express in my photographs unter-messages relating to the human experience. This anthropomorphic dimension might be seen in the 'sadness' of a drooping sunflower, or the danger suggested in a closeup of cactus thorns. Additionally, a composition that includes symmetry, recognizable forms or shapes, odd-numbered groupings, or a familiar distribution of patterns, colors and lines tends to capture the viewer's attention and invite further exploration. For example,

I might depict a beautiful cloud—comforting and appealing in its softness, but with another familiar message: the graceful shape of a woman's torso. And finally, I strive for a visceral richness of color, tactility of forms, and relationship of tones. I look for a delicious, sometimes creamy and sometimes rhythmic feast of middle values, strong and solid. I use very dark and very light tones carefully and sparingly. They become visual landmarks or references for the immediate messages carried by the interplaying middle tones. It is similar to piano composition in that most works are dominated by the quantity of middle notes, using the relatively fewer lows and highs more as musical seasoning. Just as photographic work is like musical composition, art is art, no matter the medium. Artists will use what they can to create their works and deliver their messages through their art.

Tuttle's unique vision is informed not only by his background, but also his overall and continual immersion and interest in the creation of things: beautiful and fascinating art, beautiful and fascinating machines. He is, after all, an engineer and inventor, a poet and composer—and an artist. There is a totality in his work, as each piece is more than a sum of its parts. Tuttle is proof of the deep connection between science and art, the intersection of the artist and scientist, and the intertwining of two ways of interacting with the world.

University of Pennsylvania professor, English biologist, and Darwin advocate, T.H. Huxley—who, himself, was known to mix a bit of the humanities with his science—underscored his own belief in "the great truth that art and literature and science are one" in his address to the Royal Academy of the Arts in London in 1887:

> It is the business of the artist and of the man of letters to reproduce and fix forms of imagination to which the mind will afterwards recur with pleasure; so, based upon the same great principle by the same instinct, if I may so call it, it is the business of the man of science to symbolize, and fix, and represent to our mind in some easily recallable shape, the order, and the symmetry, and the beauty that prevail throughout Nature.

Tuttle takes this "business" quite seriously. He has been photographing and printing for fifty-three years—shooting exclusively in black and white for thirty-six of those years. In the 1980s, he began watercolor painting, and became fascinated with color. In the following decade, empowered by the control and flexibility offered by digital cameras, he abandoned his "tones of grey," in favor of color photography. He currently shoots 98 percent of his work in color, and all of it digitally.

Tuttle has exhibited his work at numerous galleries throughout the United States, and has garnered many photographic honors and prizes. He hopes you enjoy *Watersong Circle*.

Dedication

In early 1957, my cousin Morrie Tuttle returned home to Iowa from his long stay in France. He left soon after his return—in late 1957. That was all it took for me. During those few months Morrie lived next door, my artistic fires were stoked, and my life's trajectory was altered. Morrie worked to build my first darkroom. He also introduced me to The Camera Shop in Spencer, owned and operated by a smiling, energetic and helpful man named Dick Redenbaugh.

Every day that I pick up a camera or process a print—or even when I visit an art museum—I think of Morrie and his generosity. He gave me his time. He helped fill my mind with wonderful and beautiful ideas.

Just this year, I learned that Morrie had been out of work during those months that he was back in Iowa—and looking everywhere for a job. He did not really have that time to share with me, but graciously, he willingly found a way. When he left Iowa, it was for a position in Lincoln, Nebraska, where he still lives today. He remains active in the arts, both in the Lincoln community and with the University of Nebraska.

After that summer of 1957, teacher and student did not see each other again for fifty-three years. Morrie and I met in Lincoln on Thanksgiving, 2010. It was an inspiring meeting—and a wonderful reunion.

Cousin Morrie is an exemplary human being in any regard I can conjure. I am proud to know him. And proud to consider him a friend. Any ability I have to communicate artistic beauty through photography—and particularly through the photography in this book—I owe to Morrie. It is also Morrie to whom I owe my fifty-three-year love affair with photography, and the arts in general. And so, it is Morrie Tuttle to whom I humbly and happily dedicate this book.

Acknowledgments

I wish to express my profound gratitude to three people without whom this book would not exist.

As I discussed in the dedication and biography, Morrie Tuttle introduced me to the arts, and to photography as art. The importance of Morrie's influence on my artistic life cannot be overstated, and I wish to express my sincere appreciation and gratitude for his gift.

I also wish to thank two people for their invaluable help in preparing the book. The first is Caroline De Vita, who led the design and layout, and who gently but assuredly paced the completion of each draft, exerting her expertise on my behalf with acrobatic creativity and execution, through hoop after hoop of the design process. I am also grateful to my copy editor, Julie Clement, who not only gathered and refocused my wandering texts and amazed me by giving them poise and direction, but she also introduced me to Caroline.

The efforts and contributions of these people were integral in shepherding *Watersong Circle* through the many gates of its artistic meadows. I humbly acknowledge these gracious, talented and caring individuals, as well as all of the other gracious, talented and caring people I have known throughout the world. Because of them, the beauty in the flowers of *Watersong Circle* rises to its level in these pages.

Oh yes, I almost forgot! Thanks to the bright yellow bee of Plate 50. The bee and his brethren—bugs, bats and birds—with their combined frenetic and sustained energies, and by the irony of unwitting pollinations of countless generations, have borne to the world the entire floral universe, and thus the flowers of May at Watersong Circle.

www.ingramcontent.com/pod-product-compliance
Lightning Source LLC
Chambersburg PA
CBHW051018180526
45172CB00002B/400